KODAK
Pocket Guide to
Digital Photography

D1132117

KODAK Pocket Guide to Digital Photography

ISBN 0-87985-812-5

Design: Andrea Zocchi Design
Printed in the United States of America

Kodak
LICENSED PRODUCT

KODAK is a trademark of Eastman Kodak Company used under license.
PHOTO CD, PICTURE PLAYLAND, and IMAGE PAC are trademarks of Eastman Kodak Company.
PHOTONET is a trademark of PictureVision, Inc.

The publisher acknowledges all other trademarks and registered trademarks of products featured in this book as belonging to their respective owners.

Library of Congress Control Number: 00-090674

KODAK Books are published under license
from Eastman Kodak Company by
Silver Pixel Press®
A Tiffen® Company
21 Jet View Drive
Rochester, NY 14624 USA
Fax: (716) 328-5078
www.silverpixelpress.com

Contents

Introduction:
Traditional vs. Digital Photography

The best way to understand digital photography is to simply think about "*photography*." The digital revolution has merely added a new tool to the photographer's camera bag—granted a very powerful tool.

Like film, the digital camera's imaging sensor captures the picture for posterity. You still have camera bodies, lenses, exposure modes, flash illumination and shutter speeds; all the creative tools needed to take great pictures. But now the "film" is digital.

Once the digital picture is taken, the biggest differences between conventional and digital photography become apparent. "Darkroom" work is now done instantly with the click of a mouse instead of spending hours in a darkroom with chemicals. Software has enabled photographers and other artists to use and change photos in ways never imagined in the conventional photography arena.

This book is designed to help you create better digital photographs, whether you start with film and digitize your pictures, or shoot digital originals with a digital camera.

Getting Started in Digital Photography

There are several simple steps that will help you get started in digital photography.

1. Get the Picture!

There are two primary ways to obtain a digital image. One is to "shoot" a picture with a digital camera, the other is to use a scanner.

Using a Digital Camera

The easiest way to get started in digital photography is to purchase a digital camera. Images are recorded in the camera's memory or on a memory card (such as a FlashCard or PCMCIA-II card)

Once the memory is full (you've "shot an entire roll"), you download the pictures to a computer so you can clear the camera and continue shooting. If using memory cards, you can simply switch cards and delay the download process.

The number of pictures you take before running out of memory depends on the amount of memory available, the image quality, and whether you're shooting color or black-and-white or sepia-toned.

Without a Digital Camera

Your prints, slides and negatives can be "digitized" to create a digital picture file. You can do it at home with a scanner that attaches to your computer, or you can send them out to your photo finisher or another service provider to have them scanned.

2. Image Manipulation & Software Fun

Once in the computer, you can do countless things with your image, from simple improvements in the picture to adding type or even dreaming up entirely new artistic creations. You can also add your images to emails, documents, and websites, or create fun photo novelties like T-shirts and stickers at home.

3. Emailing & Sharing Your Pictures

The Internet revolution has opened up an entirely new method of communication, and photography has not been left out. It's easy to attach photographs to e-mail so that recipients can view them. You can also have your conventional film or digital images posted on a special website by an on-line photofinishing service. Then you and family or friends can order prints from the comfort of your home.

4. Printing Your Digital Photographs

Ink-jet printing technology has advanced at an extremely rapid pace, so that affordable "photo quality" printers are readily available to the home user. Not only are they easy to use, but the results are exceptional.

Should you wish conventional photographic prints or enlargements, your digital files can be delivered to a photofinisher (in person or via e-mail).

What is a Digital Photograph?

A digital picture is simply a photograph that is expressed in "computer language" and saved as a file. The computer language describes what the picture should look like, so it can be displayed on the monitor or printed to make a hard copy.

Just like a word processing file, this picture file can be saved on your hard drive or a floppy disk, CD, or other media. It can be sent over the Internet as a file or attached to e-mail. To "read" this photographic file, you must have software that is compatible. Most picture software, for example, can show you what a common JPEG picture file looks like. Click on it, and the picture pops up on your computer monitor.

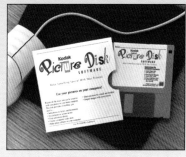

Once in the computer, this picture can be altered using photo editing software like PhotoDeluxe, Photoshop, PhotoSuite and numerous other programs. You can improve the color, crop the image, add text, distort it creatively, and the list goes on!

It's All About Pixels

In order to "describe" a digital photograph, the computer breaks the picture up into tiny pieces, called pixels (short for picture elements). Each pixel is assigned color and tonal values. These pixels are like jigsaw puzzle pieces, each holding a little bit of information about what the final image looks like. Alone, they are meaningless. But when placed on an evenly spaced grid in order, a picture begins to appear.

Bit Depth

Information assigned by computers to pixels are measured as bits or bytes. This number is referred to as bit depth. A one-bit pixel can create a jigsaw puzzle piece that is either white or black. 8-bit (or one-byte) pixels can display one of 256 colors, which makes a "posterized"

picture with choppy colors—almost like a paint-by-number picture
Pixels that contain three bytes (24-bit) or more can indicate a colo
that is one of more than 16 million, allowing the smooth, realisti
gradation of color.

 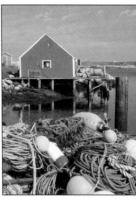

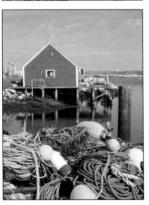

**Clockwise from top left: Black and white (literally) has jus
black and white in it. Grayscale looks "photographic" at 25
shades of gray (8-bit system). 256 colors appears "posterized
with choppy colors. 3-byte (24-bit) and higher systems off
over 16 million color options.**

Pixel Resolution

Aside from how much data each pixel holds, the total number of pixels is important. This is called the pixel resolution of an image. If you had a digital image (whether it was captured with a digital camera or scanned from a print) that measured 100 pixels wide by 150 pixels high, you'd have a pixel resolution of 15,000. If displayed at 4x6-inches, the picture would look blocky and unrealistic, because the individual pieces would be so large that your eye could clearly identify them. At this size, the dots-per-inch (dpi) would be 25 (100 pixels divided by 4 inches equals 25; 150 pixels divided by 6 inches equals 25—see page 12). This value is considered low resolution.

However, if you shrink this picture to postage stamp size, the 15000 pixels would be smaller and closer together, approaching photographic quality. Photographic quality is achieved when the human eye can't differentiate between pixels and sees a continuous tone image that looks like a traditional photographic print.

The same picture at high resolution might break the image into 1600 pixels wide by 2000 pixels high; a pixel resolution of 3.2 million. At 4x6 inches or larger, this high resolution digital image would yield photographic quality results.

High resolution picture files give more choices than low resolution files because they can print at small sizes with good results. Conversely, you will have problems with image quality if you enlarge low resolution pictures beyond a certain size.

Pixels Equal Memory

Since high resolution pictures look more realistic than low ones, why would anyone ever consider working with less than the highest resolution possible? Unfortunately, pixels eat computer memory at a very high rate. The higher your resolution, the longer your processing time. Also, high resolution cameras and scanners are more expensive than lower resolution models. It is most efficient in terms of time

and money to use only the degree of resolution required to produc an acceptable output, whether that end product is a small image o your computer monitor or a wall-sized photographic print. Refe to the chapter on printing and output beginning on page 49 fo more details.

The Elusive DPI

One confusing concept in digital photography is dots-per-inch (dpi) especially as it relates to pixel resolution.

Pixel resolution is often expressed as the product of two values, suc as 300 pixels high x 450 pixels wide, or 135,000. This tells the numbe of pixels on the vertical side of an image multiplied by the number c pixels on the horizontal side.

Dpi is a mathematical description that refers to output, such as a image on a monitor or a print. Computer monitors, for instance, ar set at approximately 75 dots-per-inch (75 dpi). So, every linear inch c picture on screen will consume 75 dots (pixels). In the example above the monitor would take the 300 vertical pixels and use 75 on the firs inch of display, another 75 on the second, and so on—displaying vertical inches. Since 450 divided by 75 equals 6, the long side woul be 6 inches. Hence a 300x450-pixel picture looks fine at 4x6 inches o a 75 dpi computer monitor.

12

Contrast this with an ink-jet printer that might give the best results at 150 dpi. Now the printer is going to use those pixels at a much faster rate. Needing 150 pixels per inch, it will deliver only a 2x3-inch print at this dpi (300 divided by 150 equals 2; 450 divided by 150 equals 3).

For magazine reproduction, the printer may need 300 dpi for quality results. In this case, the pixels will be all used up by the time you reach 1x1.5 inches.

In all three examples, if you were to print or view the picture larger than the sizes listed, quality would begin to suffer. You would begin to see "pixelation," which is the appearance of the image breaking up into dots, not unlike the appearance of grain from high-speed conventional films. Thus, it is important to understand both dpi and pixel resolution. See the chapter on printing for more detailed information.

Raster vs. Vector Files

Another point to clarify is the difference between raster files and vector files. A raster file is a bitmap—a grid of pixel elements with their own assigned color and tonal values. Digital photographs are raster files. They are limited to the number of pixels contained in their files. If they are enlarged too much in printing, you'll get pixelation. Likewise, bitmapped text fonts suffer from "jaggies" (rough, jagged edges) if they are enlarged too much.

A vector image is produced by mathematical commands or equations. These equations describe how a line should look, how an area is to be filled with color and tone, or what exact shape a curve should form. An example of a vector image is a drawing created in Adobe Illustrator software. Since vector image information is mathematical to start, it can be scaled up and down without affecting the quality. So your vector output is not limited by pixel resolution. Vector type fonts are smooth and perfect no matter what size they are printed.

Digital Photography
Without a Digital Camera

You don't need a digital camera to create digital photographs. Any picture can be "digitized" and turned into a digital picture file. Even if you own a digital camera, at some point in time you may want to convert your pre-digital family prints, slides and negatives into digital pictures. You may even want to turn your children's finger paintings into e-mail-able digital pictures. This chapter will show you several easy ways to do this.

Scan Your Photos at Home

You can scan prints, negatives or slides at home with a scanner that attaches to your computer as a peripheral. Some are available for under $100, while professional models can cost thousands of dollars. Basically, the scanner interfaces with your computer, and takes a pixel-by-pixel digital picture of the original. This is called "scanning" or "digitizing" a picture. It takes a little time to get the hang of scanning your images, but it soon becomes second nature.

Flatbed Scanners

Flatbed scanners are by far the most popular and easy to use. Simply lay your print, drawing, or fabric face-down on the glass surface. Flatbed scanners can also be used in conjunction with optical character recognition (OCR) software to convert a printed page into a word processing file that can be edited on your computer. Some models offer accessory transparency adapters for film. Low-end scanners are good for small prints and e-mail pictures, but you most likely will have to spend quite a bit more for high resolution, high quality models.

Film Scanners

If you plan on doing high resolution, quality work with 35mm slides or negatives, you might need a dedicated film scanner. They are far more expensive on average than a flatbed scanner, because the enlargement factors

with film are much greater. (Remember that photographic prints have already been enlarged to make the print. So to "catch up" and bring a 35mm slide or negative up to 4x6 inches, you're already at a 400% enlargement. Though your flatbed might have a transparency adapter, it probably won't offer professional quality.

APS Scanners

If you shoot with an Advanced Photo System (APS) camera, you can purchase a scanner made specifically for APS film canisters. Simply insert your processed APS film canister. The scanner will access the film, digitize it, and display a digital index print on your computer.

Print-Fed Scanners

Print- or sheet-fed scanners are usually very small and very easy to use, but you can usually only scan prints up to 4x6 inches. The scanning resolution is also comparatively low.

Document Scanners

Be careful when considering document scanners built into fax machines or made specifically for scanning documents. They are often low resolution scanners designed to copy text for Optical Character Recognition (OCR). This is a valuable technology because it converts a page of text into a word processing file,

allowing you to edit on your computer. But it does not necessarily make high quality scans for photographic purposes.

Digital Cameras as Scanners

Don't forget that your digital camera can serve as a scanner as well. It views a scene and "digitizes" it. You can create a digitized version of an existing photographic print if your camera has close-focusing capability and a telephoto lens. Take a picture of your print and you now have a digital image. Low-end digital cameras will probably not let you focus closely enough to achieve this.

KODAK PictureDisk & Picture CD

The easiest way to get your photographs "digitized" is to check the box on Kodak processing envelopes that requests a KODAK PictureDisk (floppy disk) or PictureCD. For a few extra dollars, you'll receive your prints *and*

digital picture files for every image on the roll of film.

Free software on the disk, CD or Kodak Web site will automatically show you a slide show of all the images; you'll be offered picture editing tools for automatically improving the color and contrast and creative tools for "stylizing" the image. Software for e-mailing, printing and organizing your pictures is also included.

KODAK PhotoNet Online

If you have internet access, a convenient option for posting images is to use the KODAK PhotoNet online site on the World Wide Web. You are given a private password that provides access to your pictures. Simple interactive e-mail order forms let you purchase prints or photo novelties. For a small monthly membership fee, you can also use the site as your online photo library to permanently store your photos.

You can share your password with friends and relatives, who can look up the pictures and order their own reprints directly. You no longer have to guess which pictures in what sizes they'll want to own. You can even delete the bad or embarrassing images before sharing your password.

Other Methods

Video frame grabbers, such as Snappy! can be used to "grab" still images off conventional videotapes, television or game consoles. The quality is not the best, because most video camcorders are not

Understanding & Using Scanners

The key to understanding scanner resolution is the *per inch* part of dpi. At a 300 dpi setting and 100% enlargement (actual size), a scanner creates 300 pixels for every inch of the original. If the original is a 4x6-inch print, it would read 300 pixels for each of the print's 4 inches of height, for a total of 1200 (4x300=1200) pixels.

The scanner head would then travel down (or pull the print across) its path for the entire 6 inches of its length, creating a total of 1800 pixels (6x300=1800). Hence the pixel resolution of this newly created digital picture file would be 1200x1800. It would include a total of 2.16 million pixels (1200x1800= 2,160,000).

However, if the original was a 35mm slide (about 1x1.5 inches) scanned at 300 dpi and 100%, the pixel resolution would be much different, even though the dpi setting is the same. The 1x1.5-inch image would have 300 samples taken per inch for its height (1x300=300) and 300 samples per inch for its width (1.5x300=450). The result is a much smaller pixel resolution of 300x450, with a mere 135,000 total pixels (300x450=135,000).

If both these scanned images were then printed on a 300 dpi

designed for still images. They are usually low resolution, and blurring is common.

Many digital video (DV) camcorders offer still image capability in addition to motion. Top of the line DV camcorders are versatile as both a camera and video camcorder. They can produce fairly high resolution, high quality still images.

Clip-Art or copyright-free photographs are available from many software companies, as well as government organizations. These are pictures taken by other photographers, but you either buy or are granted the right to use them for your own purposes.

clip art

printer, they would look great at their respective original sizes—4x6 and 1x1.5.

Since most of us don't want to print our 35mm slides at their actual postage-stamp size, much higher resolution scanners are needed for slides than prints.

The Enlargement Factor in Scanners

It can become more confusing when the enlargement factor comes into play. Scanners usually offer you the choice of what dpi to scan at, as well as what size enlargement to make. Both these items affect the pixel resolution size. For example, if the image was scanned at 300 dpi and 200%, instead of 100%, things get more complex mathematically.

In the example of the 4x6 print, scanning at 200% and 300dpi is the same as scanning an 8x12-inch print at 100% and 300 dpi (because 8x12 is double the size). Alternately, you'd get the same results by scanning the 4x6-inch print at 100% and 600 dpi.

Unless you enjoy mathematical puzzles, I'd recommend selecting the amount of enlargement or reduction you want in terms of percentages (1.5 times bigger being 150%), and setting the dpi to the recommended dpi of your output device (such as your ink-jet printer).

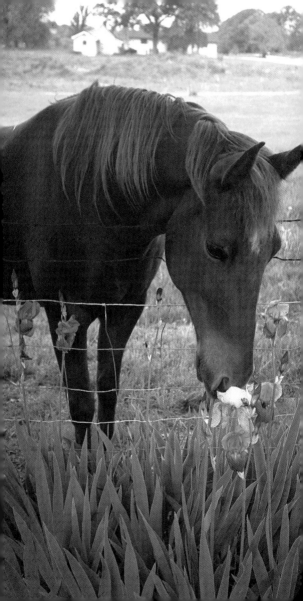

Selecting the Right Digital Camera

Probably the most fun way to get pictures into the computer is with a digital camera. Compose and shoot your picture, then transfer it to the computer. Within seconds you are able to print it at home or e-mail it across the world! Picking the right digital camera will determine how much you enjoy this process.

Long-Term Savings

The prices on digital cameras have dropped at a terrific rate. Technology that cost tens of thousands of dollars a few years ago is well under a thousand dollars. And entry level, low resolution digital cameras can be purchased for under $100.

But that still might not help the "sticker shock" when faced with buying a new digital camera. The initial investment on a quality camera might seem high, but you must factor in the long-term savings: *no more film and no more film processing*. With traditional photography, you pay for the film, the processing and the print, even if the picture turns out to be a "loser." With digital, you can review the picture on the camera's display panel, and erase it on the spot if you don't like it. After you've transferred your pictures to your computer, you erase the camera's memory and start shooting again. Your only financial outlay is for new batteries (unless of course your camera uses rechargeable batteries!), ink and paper.

Do the math: Total the cost of one film roll plus processing, then multiply by the number of rolls you shoot in a year. You may be surprised how quickly you can "pay off" your new camera in savings. Of course, you'll need to consider the cost of ink-jet paper and supplies for prints, but you'll find you don't print every image—just the very best.

Camera Type

There are numerous types of digital cameras, ranging from ultra-simple low resolution point & shoot cameras, to professional cameras costing tens of thousands of dollars. Three of the most common types are: entry level point & shoot, megapixel point & shoot, and SLR style digital cameras.

Entry Level Point & Shoot

Affordable point & shoot digital cameras are fun to learn and use, not unlike their conventional film counterparts. Some offer many advanced features like removable storage media, while others are no-frills. They tend to be low resolution units good enough for producing images that will be viewed on a computer monitor (like e-mail attachments) or printed only 4x6-inches and smaller.

Point & shoot digital cameras are designed to be non-intimidating and are usually user-friendly. Many of this variety are similar to each other, offering maximum automation in terms of autofocusing, exposure control, flash control, image review, and image transfer. If you are proficient with a conventional camera, you may not even have to read an instruction manual to get started with digital. But read it anyway. You don't want to miss any key features.

Yet all this automation has a drawback. There are few manual overrides or user-selectable options.

Megapixel Point & Shoot Cameras

The low resolution point & shoot camera is being quickly replaced on the market by the so-called megapixel cameras. These cameras offer over one million pixels in resolution, some considerably more. Don't be lured by pixel resolution alone, however, especially if control of the camera is important to you. Many of these cameras are

point & shoot simple—and point and shoot *limited*—in terms of user-selectable features. Others offer features that were previously reserved for the higher end, SLR-type digital cameras. Scrutinize the features carefully before deciding on a model.

SLR Cameras

SLR digital camera systems are much more expensive but offer the shooting control you'd find in their conventional film counterparts. They also offer much higher resolutions, making them more useful to professionals who have their photos published as full page or larger magazine images.

SLR digital cameras offer creative control by letting the user select exposure, focusing modes, and interchangeable lenses. Of course, most have automatic options as well.

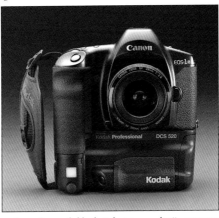

These cameras have been dubbed "photojournalist" cameras because the press was the first group of professionals to embrace them. Deadlines are paramount in the news business, and you can imagine the impact of professional digital cameras that can deliver pictures to a newspaper office halfway around the globe seconds after the images were taken.

Digital Video

Digital video (DV) deserves a small mention here, because some digital camcorders offer still picture capability. Check and find out the resolution of the still pictures. If they meet your needs, you might do well to have the choice of video and still pictures in one machine. However, only high priced DV camcorders offer high resolution still pictures.

On the flip side, some still digital cameras offer "burst of motion" capability, usually low resolution clips that last only a few seconds. It's a nice capability for the family photographer who wants more versatility.

Understanding Digital Cameras

Image Capture

By far the most common digital image recorder is the CCD (charge-coupled device). Most cameras have area array CCDs, meaning the actual image-recording sensors are on a grid, usually rectangular in shape, like that of traditional film. The capabilities of the CCD results in the camera's resolution.

Pixel resolution makes a huge difference in the quality of your digital picture and the detail captured. Inexpensive cameras tend to have low resolutions that yield images that may look good on a computer monitor, but can only be printed successfully at very small sizes.

Be forewarned that as pixel resolutions go up, the relative price of the camera and the size of the picture files radically increase.

Megapixel Resolution

A familiar term in relation to digital photography is megapixel, which refers to cameras that are capable of capturing one million pixels or more. The 3.1 million pixel CCDs provide enough resolution for digital pictures to be printed 8x10 and larger.

Multiple Picture Resolutions

In addition to how high a resolution the camera can shoot, being able to select different picture resolutions is helpful. If you're only going to use pictures for e-mail, you can shoot low resolution pictures. These utilize less memory, so you can shoot and save more images before needing to download.

Digital Memory

Another extremely important aspect of the digital camera is where it saves the image. Many low-end cameras record the image internally

on the camera's "hard drive." This is all right until you reach the memory capacity of the camera. If your desktop or laptop computer is nearby, there is no problem. Simply connect via cable, infrared, or data port docking; download the images; save them; and start shooting again.

But you may not want to carry your computer with you, or you simply may not have the time to download. In these cases, it's great to have a camera with one of the many types of removable memory cards. Like film, you load the card into the camera, record your images onto it, remove it when it's full, and replace it with a blank one to begin shooting again. The advantage is that there is no processing

other than dropping the card into a card reader or drive that lets your computer access the information. You can then erase the card and reuse it.

In order to gain more storage, some digital cameras even offer side by side "twin" slots for two media storage cards.

In average situations, with a camera that shoots 640x480 pixel files, you can hold about 20 images on a 2MB card, 40 or so on a 4MB card, and over 160 on a 16MB card. High resolution pictures on a 3 megapixel camera will eat up memory at 9 or 10MB a piece.

Viewfinders and Monitors

In the digital realm, the camera's viewing systems have become an important feature. Instant picture review is possible in most cameras.

If the camera has an LCD viewfinder or monitor for playback, you can view, then erase, pictures on the spot and shoot again. Cameras that do not have instant review capability require a to download in order to view photos on the computer or a TV.

Some cameras with bigger monitors let you review images in multiples to speed up the process. A few cameras offer monitors that can be rotated for easy viewing, so you can preview the shot even when you're holding the camera at odd angles, like above your head in a crowd.

Focus Type

Do not confuse fixed-focus or focus-free cameras with autofocus cameras. Fixed-focus or focus-free cameras are generally the least expensive, because they do not have autofocusing capability. Instead, they are designed to produce adequate results as long as your subject is at least four feet or so away from your camera.

Far better are the autofocusing (AF) cameras, because they actually determine how far away the subject is from the camera. Lower-end AF cameras offer only two or three autofocusing zones, while better cameras pinpoint the focus on your subject.

Exposure Modes

The simplest digital cameras often do not offer exposure modes. They simply choose the "best" preprogrammed exposure, with results dependent on how well the camera's computers analyze the scene. In the worst case, this means the camera miscalculates and reads a bright spot as total daylight, leaving you to correct exposure deficiencies later on the computer.

A few high-end digital cameras offer more control over the exposure system. They let you customize your exposures for special situations, choosing high-number aperture apertures for pictures that need to be sharper from foreground to background, or low-number apertures for portraits in which the back-ground can fall out of focus.

Over- and under-exposure (+/-) capability is another feature that helps achieve creative control. There will be times when the camera is fooled by the brightness or darkness of the scene, and you want to override its exposure settings. The beauty of instant review is that it allows you to reshoot at +1 or +2 exposure if the picture looks too dark.

If you don't want to bother with determining the apertures and exposure controls, you are probably a good candidate for a digital camera that is highly automated.

under-exposed

normal

Motion Capability

The need or desire for motion clips in addition to still images might have a profound effect on your camera choice. How smooth the

over-exposed

motion clip looks is dependent on how fast a frame rate (fps or frames per second) the camera can deliver. This in turn is limited by how fast the camera can process the information and get ready for the next image by clearing the CCD of previous information. Obviously low resolution, low-quality pictures take less time to process than higher-resolution versions.

If you're serious about wanting moving images, you may want to consider a digital video (DV) camcorder that also offers still picture capability.

Image Stabilization

Different manufacturers have different image stabilization methods, but they're all designed to reduce blurriness caused by camera shake or subject movement. Some do it through a computer algorithm that makes the correction in the digital files. Others use electromagnetic sensors that compute movement and internally adjust the lens elements to compensate.

Color Control

In-camera color management can be important. Although a digital camera's CCD is very similar to a scanner's CCD, it lacks a consistent color-corrected internal light source. Instead, as you shoot under varied lighting conditions, the camera's internal "computer" must make the best sense out of the scene.

Some cameras give you a lot of control over color. For example, you can select White Light Balance on some cameras, which will neutralize off-colored lights. But often, you might want to show the warm tones (yellower, redder light) of sunsets or the cool tones (bluer) of rainy days. In this case you would want options other than White Light Balance.

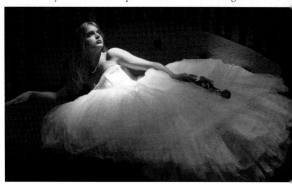

neutral color

Color shooting modes are also handy. Many cameras give you choices that include "normal" or neutral color, super saturated color, black and white, and sepia (warm toned, "antique") images. High end cameras may even add "filtered" black and white, such as a yellow or red filter. This function lightens the select colors in the image for the ultimate in creative control over your black-and-white digital images.

saturated

If your camera does not offer these handy color shooting mode choices, you can make basic alterations in most photo editing programs.

sepia

Processing Speed

Processing speed—or the equivalent of film advance speed in conventional cameras—is related to exposure time. Obviously a digital camera does not need a motor drive, since there is no film to

&W

drive forward. But it does need time to process the image. The CCD or other imaging sensor must transfer the light-induced electrical charge to be converted to voltage, which is then calculated into a digital picture file. The quickness of this task determines how long the delay is after you take the first picture until the camera is ready to shoot again.

Sound

Some cameras allow you to attach short voice memos to your photos. Identifying the subject of the picture by name and date can eliminate later confusion.

Some cameras offer a choice between simultaneous voice recording or after the fact memo recording. Check the sound quality carefully. Generally, the microphone it is not as good as a camcorder.

USB or Firewire Ports

Universal Serial Bus (USB) and Firewire ports are high-speed digital data ports for transferring information between computer and camera (or memory card reader and computer). This is especially important if

you're using a camera with motion capability, which requires the rapid transfer of data for good results.

Self-Timer

A self-timer allows you to delay the shutter release for about ten seconds so that you can take a self portrait or include yourself in a group photograph. If you don't own a tripod, the trick becomes finding somewhere to prop the camera or steady it in the exact position you want it. The handiest self-timers have a

light or audible chirp that quickens right before the exposure so yo
can prepare your best smile.

Video-out Port

A Video-Out port is a nice feature for hooking your camera to a TV fo
easy viewing. If your TV has a VCR, you can also add your still image
to videotapes.

ower Supply

attery type or the availability of an AC adapter might be important for gh volume users. Some digital cameras require significant battery ower. An AC adapter is very handy for conserving battery power when u're downloading images to your computer.

raphic Stylus.

ome cameras enable you to use a graphic stylus pen on the camera's uch-screen monitor. Results are often somewhat crude, but you can uickly add a handwritten headline or comic doodle on your pictures.

undled Software

any manufacturers offer "bundled software" with a camera purchase. e forewarned, the bundled software is often a less powerful, limited ver- on of a popular high-end software package. It could also just be a demo. heck carefully to see if the software factors into your cost.

ccessories

ccessory capability and availability should also be considered in your amera choice. The interchangeability of lenses on SLR cameras is an ormous creative benefit, giving you expanded compositional options.

A tripod screw is helpful, should you want to steady the camera for anning and creative techniques, or to create self-portraits.

The ability to add filters for creative reasons is a big plus. A olarizer, for example, can remove unwanted reflections that may ide a portion of a scene on the other side of a window. Special fects filters are still useful, but most have been replaced by their oftware counterparts.

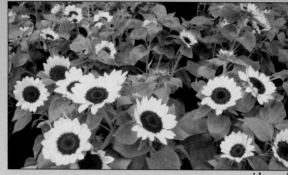

wide-ang

zoomed to norm:

zoomed to telephot

Lenses for Digital Photography

The lens on your digital camera is very important. It must possess good optical qualities to achieve results that are satisfying. It should be "fast" enough to gather light in low-light situations. And the versatility of different focal lengths is helpful because you can then capture different views in terms of picture width or magnification.

Wide, Normal, or Telephoto

Wide-angle lenses view a wide expanse of the scene, but distant objects seem especially small and far away. "Normal" lenses show the world pretty much as our eyes see it, without the peripheral vision. Telephoto or "long" lenses magnify the subject and make it seem closer in the picture.

The principles of lens focal lengths in 35mm film and APS cameras, do not necessarily translate into the digital world. It is the size of the CCD that determines focal length in a digital camera's lens. When shopping, refer to the "35mm film format equivalent," because CCD chip sizes can vary from one digital camera to another.

Single-lens Cameras

The most economical digital cameras have only one lens setting, and it's usually a wide angle. This is good for scenic photography, photographing groups of people, and general indoor photography.

Only one focal length choice means that the camera only sees one angle of view. This severely limits your creative options.

Zoom Lenses

The ability to zoom from wide angle to telephoto is a valuable feature because it allows a great deal of control over your composition, with dozens of focal lengths to choose from. You can select wide angle to capture a sweeping vista on a scenic photo, or to include every person in a large group portrait. Or you can "zoom in" for a close head-and-shoulders portrait with the telephoto setting.

Digital Zoom

Don't mistake digital zoom for optical zoom. Digital zoom is simply a electronic enlargement of the image, coupled with cropping to make seem like you are "zooming" closer with the lens. In fact, you ar enlarging or enhancing the pixels to do this. An optical zoom "bring the subject closer" *before* recording the image on the sensor, giving higher quality result. You can then enlarge the image even more afte taking the shot by cropping it in a photo-editing software program.

Accessory Lenses

Accessory lenses, such as those available from Tiffen®, offer you flexibility and an advanced degree of control over your pictures. They attach onto the front of your digital camera's regular lens, giving your camera additional telephoto, wide-angle, or close-up coverage.

wide-angl

Macro Capability

Look for cameras with closeup capability as well. Some digital cameras can focus as closely as an inch or two away from the subject. In addition to taking a closer than normal

telepho

look at something, close-up capability enables you to use your car era like a scanner to make digital pictures of artwork, convention photographic prints, or other objects you might otherwise put on flatbed scanner.

Understanding Flash

Most digital cameras have a built-in flash that can be utilized manually or fired automatically in auto-flash mode. Better cameras have more powerful flashes, and many offer advanced flash exposure modes. High end cameras might even include a hotshoe for using an accessory flash, or a PC-sync port for utilizing professional studio-style flash units.

Flash Limitations

It is important to understand the limitations of flash. The tiny flash units built into compact digital cameras can't work miracles. These small flash units are designed to illuminate close subjects, such as a person standing a few feet away. You should learn what your flash can and cannot do. For example, you might chuckle the next time you see a flash go off at a concert or baseball game; it can't possibly light up the whole stadium. The result could be a drastically underexposed picture. Instead, you should turn the flash off, increase your exposure time, and hold the camera very steady (or brace it on a solid object).

Certain higher-end cameras have stronger flashes that work at longer distances, or have a hot shoe or PC connection for synchronization with accessory flashes or larger studio flash units.

Auto-flash

If your camera has an auto-flash mode, it will automatically fire in low-light conditions or whenever the camera perceives a need. The result could be a well exposed subject and a nearly black background. Some high-end cameras will also fire if they detect a backlit situation, so your subject does not appear as a silhouette.

Fill Flash

Fill flash is one of the best features of modern cameras because it vastly improves pictures in many different situations. For example, the noon-time sun casts harsh, unpleasant shadows under the eyes and nose. These shadows exaggerate wrinkles and blemishes, and the result is generally uncomplimentary.

By adding fill flash, the shadows are now illuminated and there are highlights in your subject's eyes. This eliminates the need for computer time to lighten shadows and add highlights to the pupils.

Night Flash

Should you decide you want to mix neon lights, room lights, or a sunset sky with a well exposed subject (instead of a backlit silhouette), you can use night flash or night portrait mode. This function combines a flash exposure (which records the subject quickly) with a longer capture speed (which records the surrounding background).

For optimal results, steady the camera with a tripod or brace it against a solid object such as a railing. You can substitute fill flash for night flash if your camera doesn't have this mode, but the results won't be quite as good. Another viable solution is to take separate pictures of the background and the subject and combine them in the computer.

Flash Off

Sometimes dim lighting can be wonderful by itself, such as at dawn or dusk. But your camera's computer says "not enough light." Overrule the camera's settings and select "Flash Off" (usually a circle and slash symbol through a lightning bolt). Then steady your camera with a tripod or against a stationary object to prevent potential blur from camera movement.

Saving Your Digital Pictures

How you save and store your digital pictures can be surprisingly important. You can't just throw them in a shoebox or the bottom of a dresser drawer; the fate of countless conventional prints and negatives. Instead, you need to save them in a usable picture format, and then archive them on your computer or on removable storage media.

Understanding File Formats

If you've spent much time on the computer, you probably know that there is a wide range of software available. Many of these packages use proprietary file types. You can't always take a spreadsheet file and simply drop it into a word processing program unless the applications are compatible. The same is true in the photography business. Your digital pictures must be saved in a file format that can be recognized by the software of your choice.

Certain file formats are platform-independent, meaning they can be opened as easily with a PC as with a Mac. Others are linked to specific photo software. Some offer compression options to shrink their file size temporarily (albeit at the cost of some quality). The use of different file formats rise and fall in popularity as technology and consumer preferences change. But there are several you will consistently run across .

JPEG

JPEG (.jpg) is a compression file format that can be reduced to one-tenth the normal file size with minimal loss of detail. Compressed files take up less memory for storage and can be downloaded quicker than non-compressed files. Purists feel that any loss through compression is unacceptable, but for home use, JPEG is quite useful. JPEG's are generally not a good choice for text, line art, signatures, and sharp-edged graphics.

GIF

GIF format is somewhat outdated and is not the best for pictures. However, it works well for online signatures and other line art.

IMAGE PAC and FLASH PIX

The KODAK PHOTO CD IMAGE PAC File Format and FLASH PIX File Formats are very effective. Both are multi-resolution formats, offering either five or six resolutions in each IMAGE PAC file. This means you can choose the resolution that works best for your immediate application, such as low resolution for internet enjoyment or high resolution for large prints.

TIFF

The TIFF format is another very popular professional format for photographs. It is used extensively in desktop publishing , but is usually a very large relative file size.

Downloading to Your Computer

To transfer picture data from your camera to your computer, you will need to use a direct cable or removable memory card. The first place your digital photos usually land is on your computer's hard drive. There you can open the digital picture files and view them on your computer's monitor.

No doubt, there will be some images that might have looked great on the camera's tiny LCD monitor but fall apart when viewed on the larger screen. It is here that you will be able to see if the subject blinked during the exposure, or the image is hopelessly out of focus. This is the time to be liberal in your use of the "trash" or "recycle bin" on your computer. There is no sense in wasting computer memory space on bad pictures.

Create a Library System

Once you decide an image is a keeper, save it in your picture file format of choice (see above) and give it a meaningful name. Most cameras name the file with a default number, often based on how many pictures the camera has taken. This is fine when you have just a few

photographs, but when you start to get into the hundreds, "DC326" might not conjure up images of your summer vacation.

A mixture of key words and numbers works well. For example, "VacSF001" might tell you that this picture is the first shot (001) from your San Francisco (SF) Vacation (Vac). Using folders to group related images speeds up the searching process when you want to find a certain photograph.

Removable Storage Media

It is a smart idea to save copies of your images on removable storage media, such as floppy disks, PHOTO CD disks, or Zip, Jaz and Syquest cartridges. Should your computer crash, a virus eat away your operating system, or your house sustain a lightning hit, you could could lose data, including your picture files. And in the case of theft, fire or other disaster, the computer itself could vanish. Having images stored on separate media is simply a good insurance policy. (To protect from fire and disasters, store a set of disks offsite, at a friend's house or in a safe deposit box).

Another reason to use removable storage media is to free your computer's memory. If you have a computer with a gigantic hard drive, you can hold a large number of low resolution images without a problem. But high resolution pictures (8MB and higher in size) can eat up the available hard drive space at a very fast rate.

Web Storage

If you have internet access, you can subscribe to an on-line digital album service. You receive a private password to access your album, and software to edit and design the album's "pages." You can share this password with friends, family and business associates. These services usually charge a small monthly fee.

An on-line album is one of the best methods for sharing pictures. So long as they have Internet access, individuals living thousands of miles away can add images to the album, or order favorite prints.

Sharing Your Digital Pictures

One of the biggest advantages of digital photography is being able to share your pictures with family, friends and business associates within minutes of taking the photograph. No longer do you have to wait for the film to be processed and printed. No more "snail-mailing" letters with photos to relatives. Simply download the picture to your computer, and send an e-mail via the Internet!

Sending Images

It is certainly a joy to share images quickly with friends, family, clients, vendors, and others. Of course, this can be done by handing a removable storage disk (like a floppy, CD, or Zip) to a friend. But the faster, more convenient method is to transmit the information from one computer to another via the Internet.

Modems allow your computer to "talk" to another computer over ordinary telephone lines. They can be used to access the Internet. These modems are inexpensive, small, and portable, and can be used almost anywhere you find a telephone line. However, they are very slow compared to cable modems and digital lines in transmitting large files. One problem with modems is that a glitch on the phone line could bring the process of uploading (sending data) or downloading (receiving data) to a full stop.

Cable modems offer exponentially faster hook-ups to the Internet, as do digital signal lines—but these services are not available in all communities, and usually come at a premium price.

The Internet

The Internet is great for recreation, communication, research and shopping. Internet service providers, like AOL or your local cable company, give you a gateway to the Internet. You log on to the Internet through this company, via phone modem, cable modem or other means. Most larger Internet service providers bring you onto

their home page, where you will find member services, like a mail center for sending and receiving e-mails, access to chat groups, customer service, online technical support, games, prizes, and more.

You can use the home page as a starting point for gaining access to the rest of the World Wide Web (www).

E-mail

Probably the most often used function of the Internet is e-mail. In addition to photographs, documents of all types such as letters, illustrations and spreadsheets can easily be attached to e-mail. It's faster than mail or overnight couriers, and it can be cheaper. Plus, you can indicate multiple recipients and send one e-mail to dozens of people simultaneously.

Remember that low resolution versions of photos will download much faster for modem recipients than high resolution.

Homepage

There is no reason why you can't have your own photo website. You can either register for your own web address, or take advantage of the free "homepages" offered by many Internet Service Providers and other businesses. You can then upload your photos where others can visit your site to see them.

On-line Albums

Another way to share your images on-line is with an album service. Here, you create a digital photo album on a passworded site. You can order reprints of pictures or pages. And you can share your password with friends and relatives, so you no longer have to guess which pictures in what sizes they'll want to own.

Digital Fun With Your Photos

There are hundreds, if not thousands, of computer programs that let you be creative with your digital photographs. You can get a taste of these fun experiments by visiting the KODAK PICTURE PLAYLAND website on the Internet at http://www.kodak.com. You can create wonderful variations of your photos with a click of the mouse and then e-mail them to friends or submit them for printing.

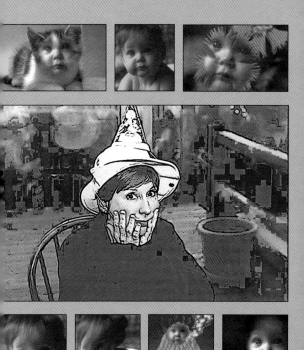

Printing Your Photos at Home

Outputting your at home pictures can range from "soft viewing" (looking at them on the computer monitor) to photo-quality printing on your ink-jet printer. Printers have become very affordable, and now offer "plug and play" simplicity.

Ink-jet Printers

Ink-jet printers are by far the most popular home printers. You may encounter other types (black-and-white or color laser, thermal wax, dye-sublimation printers, and more) in the office and professional setting, but these are outside the scope of this book. In general, ink-jets offer very smooth gradations of color. Specialized "photo" papers and inks further improve photographic quality. Many can handle thick and specialized papers and substrates. On the downside, they are slow and are suscepti-

ble to smudging. Likewise, unless using the new archival inks, they quickly fade in normal display conditions. And special paper and color inks can be expensive.

Archival Inks

You might love your ink-jet results, but unless you're using the new archival inks or a special UV coating, they are going to quickly fade if hung on the wall under normal lighting conditions. You are better off going to a service provider for your enlargements, making certain you ask specifically about long-term archival qualities. As you might expect, digital enlargements that are made on photographic papers are much more permanent.

Getting Good Results

The first way to view your photographs is on the computer monitor. Most computer monitors give a luminous phosphor display, capable of millions of colors. Yet while your photograph looks fantastic on the monitor, you may be in for a surprise when you go to print it. The mere fact that monitors are based on emitted light, and the prints are seen with reflected light, insures that the images can never be quite the same. Monitor viewing also does not require high-resolution images. The output capability or resolution of most monitors is about 72 ppi (pixels-per-inch). Thus if you want an image to appear as a 4x6-inch snapshot on the monitor, you only need a low resolution of approximately 300x450. This same resolution image would look very poor printed on an ink-jet at 4x6 inches. (See page 12 for more details.)

Numerous other variables can affect how closely the monitor image matches the printed version or how radically they differ. Among these factors are:

- The quality of your monitor.
- The user selectable brightness and contrast settings.
- The color calibration. Many monitors can be minutely calibrated with special software.
- Viewing conditions of the monitor. The lighting in your room will affect your perception of color, contrast and brightness of the image.
- Quality and type of printer and its inks, toners, dyes, or pigments. Beware of off-brand inks and papers, which may not produce colors up to the printer's capabilities.
- Quality, finish, and color of the output paper or other substrate.
- Viewing conditions and viewing distance for the output. A low resolution, pixellated image might look fine from across the room, but unacceptable close up.

Inconsistencies in lighting, inks or paper can result in radically different results. It is important to add consistency to your color printing.

Remember, too, that color viewing is subject to personal perception. Two people might like very different printed versions of the same image.

Printing & DPI

Many ink-jet printers produce nice results with 150 dpi photographs. This means that every square inch of the print requires 150x150 pixels. Therefore, a low resolution 300x450 image could be printed successfully at 2x3 inches (300 dpi divided by 150 = 2 inches; 450 divided by 150 = 3 inches), while a 1200x1500 image would make a nice 8x10-inch ink-jet print. (See pages 11-13 for a more complete discussion of dpi and pixel resolution.)

Specialty Photo Papers

There are many specialty printing papers that can be used in your ink-jet printer. In general, the smoother and glossier the paper (and therefore the more expensive!), the better the ink-jet results. High-gloss, thick photo papers produce photographic quality prints with the look and feel of conventional prints.

Iron-on T-shirt transfer papers allow you to put your favorite photos on T-shirts, quilting patches and other fabrics. Or you can buy special fabric substrates like "canvas" and "silk" that can be run through some ink-jet printers.

Self-adhesive sticker papers come in full sheets or peel-off die-cut shapes. Be forewarned: don't use ink-jet sticker papers in your laser printer, because the high heat of lasers will melt them into sticky mess!

Most commercial printers need a pixel resolution for images of at least 300 dpi, suitable for book and magazine reproduction. Ink-jet printers, however, look good at about 150 dpi, while images on computer monitors are set to about 75 dpi. Notice what happens when we drop the dpi on this picture from 300 dpi to 75 dpi for the purpose of this book.

Your Pictures and the Computer

Once you have a digital photograph in your computer, the possibilities begin. Thousands of different software programs are available that offer you diverse and creative opportunities for using your digital images. In general, they can be divided into several categories that range from traditional photographic and darkroom functions to business applications.

Image Editing and Altering

You can alter your digital photograph pixel by pixel if necessary. These changes can be of a traditional darkroom nature, like cropping, flopping, inverting, retouching, contrast control, or color/tonal enhancements. Enhancements can also be of a traditional artistic nature, such as painting, calligraphy, texturizing, or collaging.

Digital Novelties

The computer has given photography new digital-age capabilities, including morphing, stretching, twisting, "goo-ing," and other photo manipulation functions. Sophisticated collaging software enables incredible control and creativity, without the need for scissors and glue.

Image Applications

Once you've altered your images (or not), you can use them in a number of applications that enable you to incorporate digital photographs into graphic page design, word processing, spreadsheets, and novelty templates.

Desktop Publishing

One of the most popular business applications is with desktop publishing programs, which allow the design and production of newsletters, brochures, business presentations, internal memos and communiqués, catalogs, books, and other printed documents.

Professional graphics programs are complex but offer the most creative flexibility. Simpler and specialized programs provide pre-designed templates for quick and easy production.

Other Business Applications

Other business applications include Web page design, over-heads and graphics to accompany presentations and speeches, ID and security records, personnel records, photo phone books, and much more.

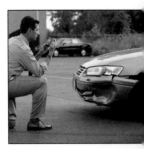

If you are in a car accident, a digital camera can come in handy to record the damage.

You can also make a record of your jewelry, artwork, cameras and other valuables in case your insured property is ever damaged or stolen. Remove and store the digital files in a safe deposit box or at a friends home, so they are not lost along with your computer.

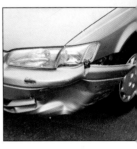

Home Applications

Family and recreational software applications are plentiful. Have yo ever considered using photographs and personalized type on your gif wrap paper? You can design it yourself with easy-to-use software, the print custom gift paper. You're only limited by the size of the pape your printer can handle.

Greeting cards & postcards have never been easier to send than the are today. Kodak and other manufacturers make prescored or die-c papers and software templates just waiting for your images and typ Alternately, you can use photo reprints from the lab and slip them in "paper frame" cards, or adhere pre-printed postcards on the back.

Your family can publish its own newsletter. It's a great way to kee friends and relatives up-to-date and it takes less time than writing stack of individual letters. Or you can issue family certificates ar awards on pre-printed or pre-embossed paper.

Kits for photo novelties and gifts include photo mugs, mousepads and jigsaw puzzles. Photo-cookies and photo-cakes are a few other possibilities. Some are do-it-yourself kits for your home printer, while others require you to send your prints or transmit your digital files, then wait for the product to be delivered.

Self-adhesive stickers can be made to order on your own computer. They come in novelty sizes and colors, or the standard business selection for office use, like address labels. With laser printers, be sure to use the special heat-resistant variety.

You can run special T-Shirt Iron-On paper through your ink-jet, thermal wax, or dye sublimation printer to create images that can be transferred to cloth fabric with an iron. Great for T-shirts, quilts, or custom garments.

Screensavers and slide shows are a fun way to use your pictures.

Terrific software packages create digital photo albums. You can select backgrounds, mats, photo sizes, and page layouts. Then you can add headlines, captions, or funny cartoon bubbles. Then print multiple copies for relatives and friends, or distribute them on the internet.

Fantasy magazine covers are always a favorite with kids. They can be the star of a sports magazine cover, or make a Mother of the Year cover as a birthday gift.

Easy, Fun Software

Software that manipulates photographs has become unbelievably easy (and fun!) to use. The images on this page were all done with a program that is popularly available. They were created in a manner of minutes—all without ever reading an instruction manual or hitting the "help" page. Kids of all ages will be able to easily create imaginative images quickly and proficiently.

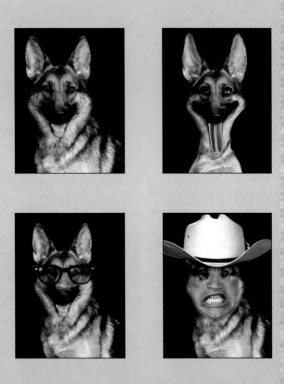

Simply load the software onto your computer, open your digital photograph in the program and start "goo-ing," "fusing," or "morphing" your photographs. Pictures change right before your eyes, and you can stretch, smush, and enlarge at a click of the mouse. You can even turn your creations into animation, as the picture goes from normal to eye popping fun. Your kids will be entertained for hours, adding Dad's mustache to Mom's face; or giving each other Pinocchio noses.

The Digital Family Album

Once you've put in the effort to shoot and edit the types of pictures you like, you are faced with the rewarding task of displaying and sharing them. You will soon be creating images so good that you will want to hang them on the wall or add them to your photo album.

Matting and Framing

You can print your photos at home on an ink-jet or other printer, send them out to a photofinisher, or upload them to an on-line lab to have enlargements made.

The most elegant way to frame a picture is to put it in a mat first. For example, you can purchase an 11x14-inch mat, with an 8x10-inch "window" cut out of it to display your picture. This mat then slips into

an 11x14-inch frame behind the glass. The mat does two things: it displays an attractive border between the print and the frame edge, and it puts a little air between the print and the glass so it won't stick.

Premade mats are available at many photo stores in a variety of colors. Look for archival mats if you want to protect your pictures from fade and deterioration.

If you don't want to spend the time or trouble framing your own pictures, you can take them to a professional framer. Make certain you request archival mat board, as it is sometimes a special order.

Choosing an Album

The album market has expanded enormously in the last few years. There are literally thousands of designs, sizes and types to choose from. Most albums fall into one of the categories below.

Plastic Smell

If your album smells like plastic, don't use it! This means it will probably destroy your photographs within several years, if not sooner. It will start by discoloring prints (often fading them to just reddish tones) and it might actually lift off the emulsion from the print. Look for albums that are labeled "archival," "photo-safe," or "acid-free."

"Magnetic Pages"

These albums were once very popular because they were so easy to use. Slip the photo under the clear plastic cover and it magically stuck in place. Unfortunately, this type was among the worst offenders in causing pictures to deteriorate. If you really love this style of album, there are one or two manufacturers out there who make "picture-safe" versions.

Bound Slip-In Albums

These albums are great because they make it easy to slip the photographs into clear plastic windows. Unfortunately, the windows are limited to standard sizes and shapes. If you want to intermix vertical and horizontal pictures, you will have to turn the book this way and that to see the images properly.

Binder Albums

Albums in binders take a big step toward correcting the format problems mentioned above, because you can mix the order of pages with different sized windows. Many people don't like the feel of a binder however, and prefer a bound album.

Scrapbooks

Unquestionably, scrapbooks are the most versatile type of album. But they are also the most time consuming. If you enjoy crafts projects, this is the album for you. You can secure photos (or other memorabilia

with archival glue sticks, two sided photo tape, or photo corners. Add text, drawings or dried flowers to make it a very personal and unique album.

The Most Modern Album!

There exists on the market an ultra-thin computer monitor that continuously displays your photographs as a non-stop slide show inside an attractive frame. This is perhaps the most unique photo display product to come out in years. The frame is actually connected to the Internet via phone line, so you can change the pictures remotely or send messages, or download weather and stock quotes.

Imagine the possibilities! You can place one of these frames in your mother's house even if she doesn't have a computer. Imagine her delight in waking up to new photos of her grandchildren or birthday greetings downloaded from your computer 1000 miles away.

Erase the Losers

Even the best photographers in the world sometimes take bad pictures. It's perfectly okay to erase the bad images. In the photo business, throwing away the poor shots is called "editing your pictures." It's a great practice for home users as well.

Two or three really good photos of Thanksgiving often tell a story better than dozens. This is because the impact of good shots is diluted if the family album is cluttered with too many mediocre shots. For example, if you have a favorite photograph displayed in a frame on your dresser, it has strong visual impact. But if you added 50 more to the dresser, that one great photo would be lost in the confusion, and you most likely wouldn't pay much attention to any of them (except when it's time to dust!).

Lastly, don't feel bad about taking bad pictures. Part of learning how to become a better photographer is by experimenting—and not every experiment is going to work. And even the best professionals throws away a lot of their images.

Tell a Story

Aside from throwing out the bad shots, you'll want to think about the "story" of your family event. An album is for sharing and remembering, so pictures (or series of pictures) that tell a story are important.

Before you pick up your digital camera, spend a few moments making a mental check list of possible shots. Just like a movie director, you need to ask yourself what "scenes" do I need to capture to tell the whole story of this event. You don't need to take all the shots you dream up, but it will prepare you to be ready if the opportunity arises.

For example, if your son is about to play his first Little League game, it's obvious you'll want to shoot the action. But to tell the story of that game, you may want to consider some of the following pictures as well:

- Your son practicing with your spouse the week before
- Trying on his uniform for the first time
- Dad helping him tie his cleats before the game
- Nervous pregame whispering
- The highlights of the game, of course
- A picture of his sister intensely watching the action
- A wide-angle shot showing the kids on the bench cheering
- The celebration dinner at his favorite pizza place

When it comes to sharing your album with friends and family, you'll notice a big difference in the impact your album leaves if you've edited out the lesser photographs and tried to tell mini-stories. Your friends might not know why they're enjoying the viewing experience so much, but you will!

The Best Intentions...

Everyone always has sincere plans to record family progress with their camera. What generally happens, however, is that is a plethora of

photos are taken when you first buy a camera, and then your output dwindles considerably as the novelty wears off.

The best way to insure this doesn't happen is to make photography part of your lifestyle as well as one of your family traditions. Always plan on bringing your camera to family outings and sports events, and keep holidays synonymous with photos. I like to keep my camera in a very accessible place, such as near the door where I hang my keys. That way, it's within easy reach as I'm rushing out of the house.

Junior Photographers

Photography can be a fun way to empower kids. They've seen you take photographs for years, and children usually enjoy the chance to partake in this "adult sport." There are several inexpensive, low resolution digital cameras available for kids, some in popular Barbie and other kid themes. You can teach your children the basics of camera care and shooting technique, and then give them a paper and ink allowance, along with plenty of encouragement.

Get them involved in the family album as well. Let them pick some shots to include, draw pictures for scrapbook pages, or decide what pictures they would like to enlarge and frame for their room.

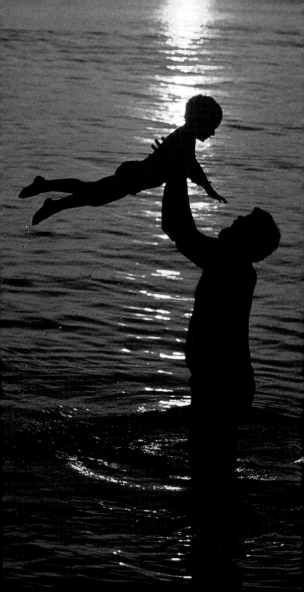

Lighting and Photography

Light is the single most important element in both digital and conventional photography because it has such an important effect on how we see our subject. It can be soft and diffuse, or hard with deep shadows, It can be natural, modified, or man-made. There are many ways that you can use lighting to affect the outcome of your photograph.

Bright Sunny Days

The sun brings out strong colors, and there is usually a wonderful blue sky in the background. It's great for bold landscape pictures, especially when you use the dark shadows for compositional impact.

However, with portraiture, the sun can cause harsh shadows on your subject's face, especially at noon when the sun is at a high angle. By shooting with the sun at your back and your subject facing into the sun, you can reduce some of the shadows. However, this often causes the subject to squint or frown—and this wrinkling of the face looks exaggerated because of the harsh shadows.

If you and your subject were to rotate in relation to the sun, the eyes will fall into shadow (cast by the nose and eyebrows), eliminating squinting but obscuring the eyes. Not very flattering! Solutions include:

Move into the shade or wait for a cloud to pass overhead.

Wait until the angle of the sun is lower (afternoon, early morning, or winter!)

Best yet, use fill-flash. The subject can even wear a hat to reduce squinting, while the fill flash lights up the darkened shadowed area under the brim.

Overcast Days

This might not be the "best" weather you can imagine from an enjoyment point of view, but it's perfect for subjects like portraiture and flowers. Cloud cover diffuses the sunlight creating soft, complimentary lighting. You'll still see shadows, but they are minimal—just enough to show the contours of the face or flowers without emphasizing wrinkles or blemishes.

Northern Light

Long before the advent of electricity, the painting Masters set up North facing studios so that their subjects were lit with flat, diffuse light from the windows. Diffuse lighting brings out the subtle contours of a person's face without casting harsh shadows or making the subject squint. Plus you can shoot indoors regardless of the weather outside.

Backlighting

Most photo books tell you to avoid backlighting (where your subject is lit from behind). But who hasn't seen a magnificent sunset silhouette? That's backlighting, after all! Successfully backlit pictures depend on planning the effect you want to achieve.

The most important procedure in backlighting is to insure that

our subject is directly between your camera and the light source. Silhouettes of people against bright backgrounds like the sky can be wonderful. The trick is to pose your subjects (or reposition yourself) so you can discern the form of their body. For example a profiled face gives more information (the shape of the nose, chin, lips, etc.) than the silhouette of the back of a head (a circular blob).

You can also combine the backlighting with flash to illuminate the front of your subject and still capture a beautiful background, such as a sunset. On many cameras this can be achieved with Night Sync (sometimes called Slow-Sync) Mode or Fill Flash Mode. (See page 37 for more information.)

Backlit photos of translucent objects tend to make those objects glow with color. This is especially effective with leaves and flower petals, as well as stained glass and fabrics.

Often you can use backlighting to highlight or rim-light the edge of your subject, for example hair that is blowing in the breeze. Moving slightly to one side will show more of a "lit rim", forming a crescent moon of light on a person's head. You may wish to add fill flash so the front of the subject doesn't fall into dark shadows, unless a silhouette is the effect you're trying to achieve.

Photographing the Light Source Itself

Sometimes you may wish to include the light source itself in the picture. If your source is extremely bright, like the sun at sunset, you will have a backlit situation. Often, however, the light may be a candle, streetlight or house lamp that gives off relatively little light. If your digital camera has good low-light capability, you can steady the camera and create a very realistic photo that shows the glowing light in proportion to the scene.

Flare

Flare is a common condition caused when direct sunlight hits your lens It can create glare, light streaks, or lowered contrast in your pictures Though hard to predict, flare can sometimes cause happy accidents However, you'll usually want to shade the lens from direct sunlight.

Time of Day

Late afternoon and early morning sunlight have a warm glow. This is because they are at an angle to the earth and pass through more of the atmosphere than at high noon.

Pollution, dust and volcanic ash can all add warmth to the light as well. This is why polluted cities often have the most spectacularly colored sunsets.

The Color of Light

This book is not the place for a scientific discussion of the "color temperature" of different light sources, but you do need to know that different light sources have different colors. For example, when you move into the shadows, the light is cooler (bluer). Go indoors under tungsten or household bulbs and the light appears warmer (more yellow and red). Flash is daylight balanced.

Our eyes adjust quickly to changes in color, but digital cameras (and film) do not. For example, when you put on a pair of pink sunglasses, the world looks pink for a few moments, until our eyes and brain "normalize" the light to "white."

Many digital cameras have a White Light Balance function that neutralizes the light and removes much of the overall color cast. Check to see if and when your camera utilizes this control. There will be many times that you do *not* choose it, such as when you want to record the warm tones of late afternoon sun, or the cool blue color of a rainy day.

The Color of "White" Light

Daylight (above) is bluer than household bulbs (below), which are yellower.

Better People Pictures

If you've ever seen a picture of yourself that you disliked, it's quite possible you can blame the photographer! There are definitely a few easy "tricks" you can use to improve your photographs of people, from small changes in your composition to utilizing the special features of your digital camera.

The Eye-level Rule

The number one way to improve most people pictures is to choose your eye level carefully. Most people pictures (and pet portraits) are best if you are shooting from the eye-level of your subject.

For toddlers, this means getting down on your knees. For a seated subject it means squatting low. For someone shorter than you, you should duck down. And stand on something to shoot someone considerably taller.

The reason behind this rule is that when you're looking at a person from a vantage point that is above or below them, there is usually some optical distortion, especially with wide-angle lenses. Your toddler, who is straining to look up at you is not only in an awkward position, but his head looks huge and his feet tiny.

A second reason is that an eye-level conversation tends to be very intimate. The same can be said about an eye-level picture, which metaphorically is a conversation between the subject and viewer.

Test the theory if you have doubts. In nine out of ten cases you'll see a big improvement.

Breaking the #1 Rule

In order to "shake things up" on occasion, the eye-level rule can be broken for creative purposes. We are used to looking down on kids and pets because we are taller. Switch it around, look up at them, and you'll suddenly have a very unusual picture. Likewise, an extremely high, overhead angle can be unusual. Remember that "unusual" may be good or it may be bad—it all depends on your degree of artistry and the creative choices you make.

People are Vertical

People are taller than they are wide. Therefore it makes sense that vertical compositions are more natural than horizontals. However, our cameras are designed to be held horizontally. It takes a little practice, but you need to become as adept at clicking the shutter when holding the camera sideways as when holding it normally.

Practice in front of the mirror the first time to make sure you're not covering the lens or flash with your fingers. And turn it so the flash is on the

top, not the bottom, if possible. I had a camera once that took great pictures. But for some reason, whenever I turned it for verticals, my hand would cover the flash. And I wouldn't realize it until my finger got hot from the flash output, at which time it was too late and the picture was lost. Despite the fact that I liked every other aspect of the camera, I knew I would lose too many vertical images. So I traded it for another model.

Note that the Rule of Thirds (see page 83) can apply equally well to horizontal and vertical compositions.

The Good Side

Head and shoulders portraits are the staple of the portraiture market. Because no human being is symmetrical, every one has a "good side," an angle that they look best at. The trick for the photographer is to figure out what that good side is, and then bring it out through composition, positioning and lighting.

Don't be afraid to walk in a circle around the subject. This achieves two things: 1) it helps change the background in comparison to the subject and 2) it shows your subject at 3/4, straight on, profile and even backside angles.

If you don't like the lighting because it is causing shadows on the face or making the subject squint, you can stay stationary, and they can pivot in a circle. Often, there is a little dance, while you move a little and you ask your subject to move a little. It only takes a second or two, but finding the "good side" can vastly improve results.

Know When to Quit

Beware of over-directing, however. If your subject isn't fond of having his or her picture taken, a few minor changes in your position could seem like a delay lasting hours. This is especially true with youngsters, who can quickly tire of the "modeling" game.

This is a situation where digital cameras are wonderful because you can share the results instantly. And if both photographer and subject aren't happy, you can erase the picture instantly and take another. Likewise, if the results are good, your reticent model might become enthusiastic.

Groups

Posing your group is important to the success of the picture. Take a few moments to organize the people, so you don't end up with a picture that looks like a police lineup. Think in terms of stacking or layering the people. Staircases are great for putting people at different heights so everyone's face is fully visible. Or try a front row of kneeling people with a sitting and/or standing row behind them.

Set-up Shots

There is nothing wrong with "staging" your photographs. If your daughter loves tea parties, you can become a "stylist" and pick out her wardrobe for the photo, and help arrange photogenic props.

Candids

Don't beg your kids to smile for the camera or say "cheese," because even toddlers will quickly develop those forced-smile camera faces. It will make it hard to win genuine, relaxed smiles for your

photos in the future. Instead, use patience, have your camera ready, and wait for those spontaneous moments when the smiles start.

By carrying your camera with you on a regular basis and substituting candid photography for formal "line-up-and-behave" sessions, your kids will begin to see the camera as an everyday accessory. Consistently good candid photographs stem from your ability to put the subject at ease and be an inconspicuous and unobtrusive observer.

For great candid photos, watch your kids playing or working on an activity they enjoy. Compose the picture in the viewfinder and then give them a holler or greeting of encouragement. Usually, you'll be rewarded with a winning smile.

With kids, the eye-level rule mentioned earlier is especially important because of the size difference between adults and children. Crouching down and shooting at their eye-level is a good starting point for most of your pictures. Break this rule only when you have a reason to.

Interaction

Some of the most successful photographs of people, especially kids, are taken when you let them interact either with their environment or other people or pets. Catching the moment when the bride gives her little cousin a peck on the cheek can be a priceless example of "interaction."

Photographing Humor

Finding humor requires an open mind, good spirits and quick reflexes. Usually humorous moments are fleeting, so knowing your camera's operations by heart will let you respond more quickly.

Creating or staging humor is actually easier, because you don't have to rely on chance. You do, however need the creative idea. If for

example, you want to create a humorous holiday card, brainstorm with your family and friends. It might be as easy as costuming your kids as Christmas elves; or encouraging your kitten to climb the Christmas tree (again), but this time with your camera ready.

Tips For All Ages

As your children grow up, you may have to change your shooting strategy to get the best results. Here are a few general pointers.

Infants

Position your infant in a photogenic spot, surrounded by unpatterned (or simple patterned) blankets. You don't want the blankets to be a distraction with bright colors.

Position the baby near a window or use the flash. A car seat is a wonderful way to prop him up for the pictures. Use the zoom setting on your camera to crop out unimportant background elements.

Then wait for the expression you want, or try to prompt a smile or "'funny face." It sometimes helps to have someone stand next to you as "baby coach."

Toddlers

Toddler photography is akin to photographing Olympic sports because I'm betting your little subject seems to always be on the move. Your best chance is

to become practiced enough to intimately know your camera's settings so you are therefore prepared to act quickly to get the picture you want.

When toddlers see you pointing a camera at them, they'll usually come charging over to see what you're doing or to collect a big hug, making picture-taking next to impossible. Try to get them to forget about the camera by asking them to show you something (a favorite stuffed animal) or perform an activity, like smelling the flowers. A good trick is to photograph them when they're engrossed in a playful activity, like digging in the sand.

Preschoolers

Youngsters now understand the concept of photography but are probably not overly self-conscious at this age. Avoid the "cheese" or "smile" commands, because you'll teach them about phony camera-smiles! Instead concentrate on candids. This is best done by pulling out the camera when they are engrossed in an activity, such as playing in the sandbox, or cuddling the family cat.

Grades 1-6

Don't rely on school pictures as the only source of photos once your kids hit grade school. Photograph after-school activities, weekend family fun, and holidays.

From this age on, it becomes especially important to photograph their friends as well; years from now they'll find great joy in seeing pictures of their childhood buddies.

Tweens & Teenagers

Teenagers and "tweens" (the almost-teens) can be self-conscious or rebellious about photography. If you've started early and made photography a painless and fun tradition, you'll minimize potential problems.

Kids this age may enjoy being the photographer, and I'd encourage it. Responsible preteens and teens will have no problem handling and taking care of the family camera, as well as working on an "ink and paper budget." If you want them to have their own camera, there are plenty of inexpensive digital cameras to choose from. They can use their pictures in school projects and e-mails to friends.

Self Portraiture

Self portraits can be important, especially when traveling. My favorite type of self portrait is what I call the "I Was Here" picture. You can buy a postcard of the Grand Canyon, but a picture of you and your family or travel companions in front of the Grand Canyon is a much more memorable souvenir. All too often, however, you come back from vacation and there are tons of shots of the family and companions and zero of the designated photographer.

The easiest way to get this type of picture is to take turns shooting it. You're in the first picture, your companion is in the second. Asking a fellow tourist or stranger to take the picture is also a good method. Set your camera to automatic and hope they do a good job framing the picture.

The best method for "I Was Here" pictures is to bring along a tripod. It doesn't have to be a heavy professional tripod—a 6-inch "pocket tripod" that weighs an ounce or two will do just fine, if you can find a table or fence to perch it on. Then set the self-timer and walk into the picture area.

Pets and Animals

How many times have you heard that "pets are people too?" It's no wonder good pet photography follows the same rules as people portraiture. "It's all in the eyes" might be a worn out cliche as well, but it really makes a huge difference. Just as taking portraits of children, you want to concentrate on your pet's eyes. First start by getting down to your subject's eye-level. Since you probably are taller than the animal, kneel or lie down. If the pet is small, it can sit on a window sill, a person's lap, or perch on a shoulder.

You may want to try and get them to make eye contact with you. Frame the picture, hold the camera steady and then peek your eyes above the camera to make eye contact. If you're careful to hold the camera steady, the picture will still be well-framed.

You can also get their attention by calling their name, clicking your tongue or squeaking a favorite toy. But be careful not to be too interesting you they'll come bounding over in response.

If you're photographing a person and their pet, you have two good portraiture choices: eye contact with the camera (from both subjects, if possible) or eye contact between the pet and its owner, showing their bond.

Red-eye is not only a problem with flash pictures of people; it can also occur in pets.

Composing Digital Pictures

What's your subject? What is important in the picture? If you have a really clear idea about what you want to feature in a photograph, you can work to eliminate everything else.

The Bull's-eye Trap

Most people fall into the bull's-eye trap: placing their subject in the middle of the photo. The bull's-eye method of composition is rarely the best choice. A more successful method is to put your main subject off-center. Most cameras, however, work against this because they orient the focusing system on the center of the viewfinder. Instead, to place the main subject off-center, focus first on your subject using the bull's-eye method. After setting the proper exposure, "shift" the camera until you are recomposed with your subject away from the center of the scene. It seems cumbersome and time-consuming the first few times you do it, but it will quickly become second nature.

Rule of Thirds

There is a simple guideline called the "Rule of Thirds" that helps photographers avoid the bull's-eye syndrome mentioned above. Like all rules, the Rule of Thirds is just a suggestion or guideline. It applies equally to photography, painting, and other graphic art forms. The basic premise is to move the subject and other important compositional elements to areas of the photo other than the center.

Begin by imagining a tic-tac-toe board superimposed over your viewfinder. The horizontal lines divide the frame into three equal horizontal bands, and the vertical lines divide it into three equal vertical bands. Your goal is to then place significant picture elements (like your subject or the horizon) along these lines and especially at

the points of intersection. Note that since this tic-tac-toe board divides the picture evenly, its shape changes for the different picture formats, horizontal or vertical.

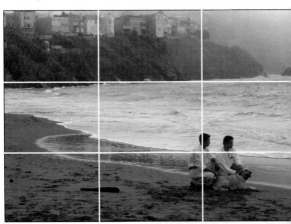

As you become more accomplished as an artist, in many situations you will soon start instinctually composing your images to the Rule of Thirds (or even more extreme off-centered compositions). You'll control the placement of important picture elements through your camera angle, the amount you zoom in or out, and your distance from the subject.

Color Counts

Everyone enjoys looking at bright colors, and they can make or break your photo-

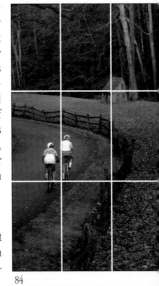

graph. Our eye is naturally drawn to bright colors like reds and yellows. These colors can be used to focus attention on important parts of the image. For example, we might wish to attract the viewer's eye to a yellow flower in a girl's hand, or to highlight a face in a close portrait by wrapping a bright scarf around it. But beware! Careless use of bright color can have an adverse effect and actually detract from your composition. For instance, a bright red sign in the background might draw your eyes away from your subject, ruining the overall effect of your picture.

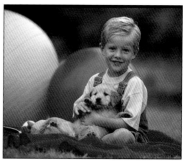

Many colors are also consciously and subconsciously associated with certain moods. If you want to create a particular mood, especially with a portrait, give careful thought to the overall color scheme (clothes, props, and background). For example, most of us perceive blues as a "cool" color, reds and yellows feel "warm," conflicting colors like blue and yellow) feel disconcerting, and harmonious colors seem more relaxing.

85

When on a "photo expedition," many advanced photographers look for colorful subjects, because they are aware of the power of colors. If they're shooting on a cold and overcast day, they may look for subjects that fit this cool, quiet mood. Or on a brighter day, if they see a great red flower, they may choose to make it the main subject, or start looking for another subject that the flower can accent.

The trick is not to be overwhelmed by color itself: you still have t create a picture that works. Remember to determine what your sub ject is before you shoot, or you might end up with just pretty pattern or "wallpaper" instead of real photos.

The Use of Lines

A horizon line is an important compositional element. Try to keep it straight in your picture. Also, just as off-centered subject composition is usually best, so is an off-centered (but straight!) horizon line.

In addition to horizon lines, our world is filled with other types of compositional lines—fences, window frames, rooflines, trees, or roads winding into the distance. The trick is to distinguish between good lines and bad lines. Bad lines are distracting, such as a pole "sprouting" from behind a person's head, or a branch casting a shadow across someone's face. Good lines draw your eye into the main subject or make the overall composition more dynamic. These lines are usually diagonal or curvilinear, preferably moving from left to right (the way we read).

Perceived Direction

Action subjects need room to move within a picture. If you shoot a person jogging from left to right, they should be positioned on the left side of the frame so they are running into the space from on the right. If you don't do this, the picture will feel cramped and crowded (such as the picture of this little girl). This goes for the direction your subject (human or animal) is looking as well. Gazing is implied movement, and it's human nature to want to "see" what the other person is looking at.

Story Emphasis

The most beautifully shot movie in the world soon becomes boring if the plot isn't good. Likewise in photography, memorable pictures tell a story.

The vertical portrait shown here is fine, but it is merely a portrait or record of what these two friends look like. The horizontal image now emphasizes the shopping bags, bringing back wonderful memories of an extravagant shopping adventure.

This new composition could be as easy as turning the camera zooming in or out, or stepping closer to your subject.

Shooting Angle

One of the rules stressed in this book is to shoot eye-level photograph of people. But you can have fun by sitting on the ground to shoot wild portrait of your friend towering over you.

Similarly a photograph of a sunflower taken with the camera on th

ground, pointed upward at the sky, can yield a dynamic picture. Likewise, you can choose a bird's-eye view (looking straight down) to shoot a bear track!

Foreground

When you study famous landscape photographs, you'll notice that many of them have "layers" in the form of something in the foreground that is eye-catching, something interesting in the background, and sometimes something in the middle. For example, an interesting foreground element, like a rock or batch of flowers, draws your attention and provides scale for a majestic background, such as a mountain range.

Background

With the exception of the type of "spectacular background" photograph mentioned above, you'll generally want to strive for simplicity. Adjust your shooting angle until you can

eliminate unwanted bold elements in the background, such as bright colors, written words (billboards or store signs), vertical lines (like telephone poles), horizontal lines, sunlit highlights, and shiny metal.

Here, in an otherwise lovely portrait, a shiny metal railing is sticking out of the model's nose. This, of course, could later be corrected using photo editing software on the computer, but that would be time-consuming and the results dependent upon the computer operator's skills. It is far easier and quicker to notice these types of problems while shooting (or just after shooting, while reviewing images on the camera's monitor). Simply reposition yourself or the model, so that a new angle of view eliminates the offending background object, or moves it to a less noticeable section of the photograph.

Get Perspective

Finding a high angle from which to shoot can also give a new perspective (literally!). High above the ground, an "eagle's-eye view" is an especially wonderful vantage point for travel photographs. Scenic flights are great fun and they yield terrific pictures as well. The toughest obstacle to overcome in an airplane or helicopter is camera shake caused by the vibration of the craft. Minimize shake by not leaning

against any part of the aircraft's frame. And whenever possible, shoot out of an open window.

Getting airborne is not the only way to get a high vantage point. Look for observation towers, church steeples, bridges, and cliffs that you can access. Not only is it fun to watch the world from these observation points, but the pictures may be very memorable as well.

Don't go too high, especially if it's a cloudy or hazy day. The view

from the Twin Towers in New York City is spectacular on a crystal clear day. But if there is haze in the air or low clouds, your view is greatly diminished. In fact, you may be better off in a 60-floor building from a photographic point of view.

Framing Elements

In the same way that a pretty frame can accent and draw attention to a painting hanging on the wall, you can create frames *inside* your photograph using objects found in the scene. Foreground elements (such as tree branches or arches) can be used to focus the viewer's attention on the *real* subject, which is found in the mid-ground or background of the photo.

The framing elements can be in focus or out-of-focus, colorful or stark, elaborate or simple. Be careful, however, to make sure your camera's autofocusing system is locking in on the distant subject, and not accidentally

focusing on the framing elements. It is better to turn the flash off in these situations because it may bounce off the framing element and either fool the exposure system into thinking it lit the distant subject (resulting in an underexposed picture) or it will turn the framing element into an overexposed white distraction from too close a flash.

Take A Second Look

When you get that itch to take a picture, you've probably found a good subject. However, your first instinct on how to shoot it may not be the best, even if you're an experienced photographer. Take a moment to review your result. Take a second shot if you see any ways you can improve it. Even take a third as an experiment. Afterall, you are not using film; you can always erase pictures that don't work.

Come Back Again

You can take this planning stage to extremes, and decide to come back for additional photos later or earlier in the day (for different angled sun), when the weather changes or even during a different sea-

on. Your results will change because the light, weather, and even our subject may change. We do this without realizing it, as we photograph our children growing up. (It's time-lapse photography in a sense.) You can also do this to document other important subjects, like your house and garden, your pets, the main street in town. You may be surprised at how different the same scene can look over days, months or years.

Add Some Scale

Anyone who has visited the Grand Canyon knows that photographs, even photos taken by professionals, just don't capture the full grandeur and beauty of this fabulous place. That's because humans have wonderful depth perception that does not translate well to film. We can understand and feel the depth of the canyon. For this reason, when shooting broad landscapes or especially large objects, you will want to include something that is a familiar size (such as a member of your family or a foreground tree) for scale or comparison.

The same is true of small objects. A close-up photograph of a butterfly doesn't tell you if it is large or small; but snap the picture when it is on a familiar flower and you instantly know if it has an enormous four-inch wingspan, or if it is the size of your thumbnail.

Patterns

Patterns and repetition of form have been a popular compositional trick among painters for centuries, and there is no reason why photographers shouldn't partake in the practice! Often the repeti-

tions can be in light and shadow patterns such as the train station shown above.

Simplify

Perhaps the most important compositional tip is to simplify! Try to minimize clutter and create simple images.

By walking around a flower cart in a busy square, a photographer can "discover" a perspective and lens setting that simplifies the subject, creating a much stronger image.

Similarly, a close-up of a bride and groom's hands can sometimes say as much—if not more—about the wedding event.

Conclusion

Digital photography is an exciting development in the world of photography. You can go beyond the traditional and use digital photography to add an extra dimension to your personal correspondence, business applications, and almost every aspect of your life in which imagery and communication is involved.

Take advantage of this new field. It can be as simple or as complex as your own needs.

Glossary

Asymmetrical Digital Subscriber Line (ADSL): A service that uses conventional telephone wires to transmit data at rates much higher than conventional modems.

Auto-exposure: A camera operation mode in which the camera automatically chooses the best possible exposure according to its internal programming.

Auto-flash: A camera operation mode in which the camera automatically fires its flash when its programming suggests flash is needed, such as in low-light situations.

Autofocusing: A camera operation mode in which the camera automatically focuses on what it deems the main subject, which in many cameras is at the center of the frame.

Bandwidth: A measure of the amount of information that can be transmitted between points within a certain period of time.

Bit: The smallest unit of computer information. One bit can provide two variables of information, such as yes/no, on/off, or black/white. Eight bits make up one byte.

Bit Depth: A measure of the amount of color information contained within a system of pixels. A one-bit pixel sees only black or white (and not gray). A 24-bit system sees 16.7 million colors. Sometimes referred to as color depth.

Understanding Bits & Bytes

One Bit

A bit has two states or possible options. In computer talk, it is either zero or one, "yes" or "no." In photography, it is black or white.

One Byte

One byte is made up of eight bits. Since each bit has two states or possible options, one byte has 256 options (mathematically derived from 2^8 or $2\times2\times2\times2\times2\times2\times2\times2 = 256$). In addition to black and white, this leaves 254 other options.

Therefore, a 256-level gray scale is possible, which the human eye sees as a continuous-tone monochromatic image, akin to a conventional black-and-white print. Alternatively, 256 colors can be created, but the human eye sees this as abrupt transitions of color, or a posterized image.

Three Bytes

A 24-bit system is made up of three bytes. In a color photography, each primary color (red, green, and blue) would be assigned a byte of information and have any of 256 different levels of brightness. Together they would yield over 16.7 million possible color variations (mathematically derived from $256\times256\times256 = 16,777,216$). The human eye sees this as the smooth transition of color (continuous tone) or photographic quality.

Over 24 Bits

24-bit systems are quickly being surpassed by even higher systems. Some manufacturers are using these extra bits to offer billions of colors, while others are maintaining the 16.7 million colors and using the extra information to improve image quality in other ways (such as aiding compositing functions).

The only downside is that more bits of information increases file sizes. (A 32-bit system will have files approximately 25% larger than a 24-bit system for an image with the same pixel resolution.)

Bitmap: A grid of pixel elements, each pixel with its own assigned color and tonal values.

BPS (Bits Per Second): A measure of the speed of information transmission.

Byte: Eight bits of information, enough for 256 variables (2x2x2x2x2x2x2x2 = 256).

Capture: Acquiring information, such as with a digital camera or scanner.

CCD (Charge-Coupled Device): A device that converts light into an electrical charge that is then converted to voltage to create a digital image. How many light-sampling points a CCD makes determines the pixel resolution it is able to create.

Clip art: Electronic files of photos and artwork that, once purchased, can be used without royalty payments.

CMOS: Complementary Metal-Oxide Semiconductor. This is an imaging sensor that is used in some digital cameras and scanners instead of the more common CCD imaging sensors.

CMYK: An acronym for cyan (bluish), magenta (pinkish), yellow, and black, the four colors of ink that make up conventional four-color printing used to produce most magazines and books.

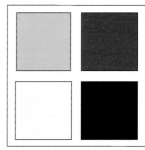

Color Gamut: The range of colors a digital camera, scanner, printer, or other peripheral can capture or create. A color that is "out of gamut" is beyond the capabilities of that equipment.

Color Management System: A combination of hardware and software that works to calibrate your input and output devices to their respective specifications. This helps to close the gap between what you see on your computer monitor and what you will see on the printed output.

Copyright Law: An international law that is designed to protect photographs (and other creations) from being used without the permission, knowledge, and/or compensation of the creator. See the sidebar on page 101.

Depth of Field:
The area or plane from foreground to background that is recorded in sharp focus.

shallow depth of field

Desktop Publishing (DTP):
The creation of documents using a personal computer, printer, and layout program that integrates text and graphics.

Digital: Data represented by numerical values based on a binary coding system (either 1 or 0).

extensive depth of field

Dot Matrix Printer: An output device that uses tiny metal pins to strike an inked ribbon to print text and graphics.

DPI (Dots Per Inch): A measure of the resolution of a printer or scanner. In general, the more dots per inch, the better the detail reproduction.

Driver: Software that allows a peripheral device, such as a printer or scanner, to communicate with the computer.

DSL (Digital Subscriber Loop): A method of Internet access that uses phone wires, without interfering with phone, fax, or modem operation.

Dye Sublimation Printer: An output device that uses gaseous dyes to form near-photographic quality images.

Dynamic Range: A measure of the ability of a scanner or digital camera to differentiate between subtle gradations of tones. Higher dynamic range figures are exponentially better than lower figures.

Encryption: The scrambling of a digital file to protect photographs from being copied without permission.

EPS (Encapsulated PostScript): A graphics file format developed by Adobe.

External Memory: Removable storage media, such as PCMCIA cards or flash cards.

File Format: The particular arrangement or structure of digital information stored from an application program.

Fill Flash: A feature that fires the flash to add some front lighting to the subject.

Film Recorder: An output device that can record digital files onto film.

Film Scanner: A scanner designed specifically for 35mm film; a few accept medium format. These scanners tend to be expensive but can scan at a high resolution and offer high dynamic range.

Fill Flash

Filter: In software terms, a function that performs a certain task, such as blurring a photograph. In photography, a filter is a glass or plastic accessory that is placed in front of the camera lens to modify the light before it enters the lens and records on film (or the CCD sensor).

FlashPix: An image file format that uses Functional Interpolating Transformational System (FITS) technology to handle large files.

Flatbed Scanner: A scanner with a glass flatbed that uses CCD linear arrays that move across the material being scanned.

Frame Grabber: See Video Frame Grabber.

GIF (Graphics Interchange Format): A graphics file format used to minimize file size for use on online services. Works better for line art than photographic images.

Gigabyte: About one billion bytes.

Graphic Stylus: A direct graphic input device that looks like a pen. It is used to draw on a special touch screen that converts the pressure from the pen into lines on the computer.

Gray Component Replacement: An advanced software correction that helps improve printed output by reducing equal amounts of CMY and replacing them with black. This results in crisper, less muddy blacks.

Hard Copy: Any printout of a photograph or document.

High Resolution: A relative term that denotes a more detailed photograph with a large file size.

Ink-jet Printer: An output device that sprays quick-drying ink droplets to print onto paper.

Interface: The ability for one piece of hardware to communicate with another.

Interface Port: A receptacle that enables you to connect compatible peripherals to your equipment.

Internal Memory: Memory built into a digital camera that lets you store picture information until you are able to download to computer or other storage media.

Interpolated Resolution (Enhanced Resolution): The guess that software makes to augment the resolution after scan or digital picture has been made. Do not confuse with optical resolution.

ISDN (Integrated Services Digital Network): Digital phone lines that can move data at a faster speed than conventional phone lines.

Jaggies: A term for the rough, "stair-stepped" edges that sometimes appear in bitmapped images. Also called aliasing.

JPEG (Joint Photographic Experts Group): A graphic file format that uses compression algorithms to reduce file size; this can cause some loss in image quality.

Kilobyte: About 1000 bytes.

LAN (Local Area Network): A group of computers that are linked together (usually by cables) to efficiently share printers, scanners, software, internal e-mail, and other files.

Laser Printer: An output device that uses small dots blended together cleanly to produce professional-looking documents.

LCD (Liquid Crystal Display) Monitor:

A monitor built into your camera on which to review your digital images as you shoot. The larger the LCD viewfinder, the easier it is to review your images.

Line Art: Black-and-white photographs or drawings without any gradations of gray. Your signature is an example of line art.

Low Resolution: A relative term that denotes a less detailed photograph with a small file size.

Magneto-Optical Disk: A removable storage medium that utilizes both magnetic and laser technology.

Megabyte: About 1,000 kilobytes or 1,000,000 bytes.

Modem: Usually refers to a device that lets you transmit computer file data over ordinary telephone lines, either directly to another computer or via the Internet. Cable modems transmit data over cable TV lines.

OCR (Optical Character Recognition): A software technology that enables you to convert a page of scanned text into a word processing file.

Optical Resolution: The true resolution of a scanner, measured in terms of the actual number of readings per inch a scanner makes. Do not confuse with interpolated or enhanced resolution.

Parallax: Cameras that have separate viewing and picture-taking lenses have a problem called parallax when working at close distances. If your subject is very near, the two lens angles will see slightly (and

sometimes radically) different views of the scene. Many point-and-shoot cameras have parallax problems, which explains why you sometimes get pictures with the subject's head cut off or with your finger over the lens, even though the view looked great through the view-finder.

Parallel Interface: The ability of a piece of hardware to connect and communicate with another piece of hardware. A 16-bit parallel interface provides a "wider pipe" for more information exchange than does an 8-bit system, since twice as many bits can be swapped at any one instant.

PCMCIA (Personal Computer Memory Card International Association) Cards, Readers & Drives:

Removable memory cards that hold digital audio, and other information received from the camera. They can be used like film allowing you to change cards (as you would change film) to continue taking pictures before stopping to down-load the images. Special drives allow your computer to read the PC card files. FlashCards and other small removable storage memory for cameras often use a PC card reader to transfer data to the computer.

PDF (Portable Document Format): A format that enables digital files to be distributed and displayed as originally designed, with the formatting, typography, and graphics remaining intact, by using software such as Adobe Acrobat.

Peripheral: A hardware device connected to a computer and not part of the computer's CPU (central processing unit), such as a printer or scanner.

PICT: Apple's graphics file format for the Macintosh computer; it has the capability of holding both bitmapped sections and vector graphics.

Pixel: The smallest picture element of a digitized image; it contains color and tonal information. Pixels can be compared to grain in conventional photographic films.

Pixel Resolution: A measure of the number of pixels (picture elements) that make up an individual digital photograph. The higher the pixel resolution, the more detail you see in the picture and the better it can be enlarged. It is a fixed number, not a per-inch ratio.

Often pixel resolution figures denote the horizontal side times the vertical size, such as 1152 x 864.

Plug-in: A software addition that allows certain equipment to work within a computer software program or vice versa.

Point-and-Shoot Camera: A common name for a lens-shutter camera. This type is usually small and compact, offering ease-of-use and "point-and-shoot" simplicity.

Port: A receptacle on computers and peripherals for connecting hardware (usually with cables).

Posterization: A printing method that reduces a continuous tone to a limited number of tones (usually three to five).

PostScript: A high-level page description language created by Adobe and used on many printers. It helps translate complex graphics and page designs into information the printer can use.

PPI (Pixels Per Inch): A measure of the pixel resolution of scanned image.

Print-Fed Scanner: An often inexpensive scanner. Photographs are fed and passed in front of a stationary linear CCD array, which scans the image line by line. These scanners usually offer low-resolution scans.

Print Server:
Software that queues up printing jobs in order of receipt or priority. It can free your computer when waiting for something to print. This can be especially important in a Local Area Network (LAN) when several computer workstations share one printer.

Processing Speed: The time it takes for a digital camera to process image data and prepare for the next shot. This can be compared to the film advance or motordrive time in conventional cameras.

RAM (Random Access Memory): Temporary memory held on chips for use in current applications. RAM is necessary to run software programs and manipulate pictures on the computer.

Raster Image: See Bitmap.

Reflective Scan: The scanning of an opaque picture or document. The scanner works by reflecting light off the subject.

emovable Storage Media: Any device that can be used by mputers or digital cameras to record and share digital imaging or mputer file in-formation with compatible media. Examples include CMCIA cards, Kodak Photo CD discs, floppy disks, and Iomega Zip, mega Jaz, and SyQuest cartridges.

esolution: A measure of the clarity and sharpness of an image on screen or in print.

GB: An acronym for red, green, and blue, the three additive primary olors used to create screen images on a color monitor. This differs from rinting, which uses the subtractive CMYK colors (cyan, magenta and llow, plus black).

can: The process of converting an image into digital information.

CSI Port: A receptacle that allows you to connect SCSI peripherals your computer for communication at a fairly rapid speed.

ervice Provider: Any vendor or business that offers imaging rvices, including photofinishing and scanning—such as the Kodak cture Network.

LR Camera: A single-ns-reflex camera, conven-onal film or digital, gener-ly considered an advanced nateur or professional cam-a. Differs from a point-and-oot camera in that the ene is viewed through the cture-taking lens. Generally LR cameras offer inter-angeable lenses and

lvanced accessories like flash units and filters.

Soft Viewing: Looking at a digital picture on the computer monitor instead of printed output. Also called soft proofing.

Template: An original document file that contains the specifications and formatting (the pattern) from which you can produce other documents.

Thermal Dye-incorporated Paper Printer: An output device that uses special paper containing microencapsulated dye; the dye units are broken when exposed to varying amounts of light or heat.

Thermal Wax Printer: An output device that uses wax ribbons; thermal head melts the wax onto the paper, where it is fused with heat.

TIFF (Tagged Image File Format): A file format used in graphic page design software.

Transparency Adapter: An accessory that converts a flatbed reflective scanner into a transparency scanner. Usually it consists of a new lid with its own built-in light source.

USB (Universal Serial Bus) Port: A type of digital port for connecting peripherals that allows considerably faster data transfer than conventional ports (40 times faster than a serial port). Digital video teleconferencing and digital camera downloading benefit from the speed of a USB port.

Vector Image: A mathematical description of how a digital image should look; equations describe what a curved line looks like or how a box is filled with color. Vector files can be enlarged to any size without affecting quality.

Video Frame Grabber:
A device that allows you to "grab" still images off of a videotape, television screen, or console game to save as digital photographs that you can use on your computer.

Watermark: A visible or invisible mark or logo placed over your digital photograph to protect it from unlawful usage. It can be removed with a special device or password.

World Wide Web (WWW): The commercial sector of the internet. Individuals and companies can post Web sites to disseminate information. The pages can be simple text or include complex photos and graphics, with multiple pages linked and accessible with the click of a mouse.

Writable CD: A compact disc (CD) on which digital pictures and other computer files can be recorded for later viewing.

Photo Credits

Louise Bates: 8

Jenni Bidner: 3, 58, 59, 82, 89 (bottom), 93, 100 (bottom), 102

Don Blair for PhotoAlley.com: 27, 28, 29, 34, 53, 60, 72, 84 (top), 90 (top), 95 (bottom)

David Bolton: 5, 68 (top), 86, 91 (top)

Carol Tate Conover: 78 (top)

Cheryl Croston: 7, 47, 87 (bottom)

Peter Davies: 10, 11, 89 (top) .

Marina De Dipp: 35

Eloisa De Franco: 50

Hugh Fleming: 94

Ed Fortuna: 37

Frontier Communications of Rochester: 46

Janet Fullerton: 73

Gary Maritke: 74 (bottom)

Marty Gonzales: 48

Karen Henderson: 79

Melanie Hertzog: 66

Dwayne Jones: 65

Steve Kelly: front cover, 39 (bottom)

Janice Laulainen: 85 (middle)

Paulina Robles Madrigal: 96

Neil Murphy: 77

John Myers: 12, 26, 30 (top, center), 31, 32, 38 (top), 50 (bottom), 51, 52 (bottom) 56, 57, 64 (top), 67, 68 (bottom right), 69, 70, 71, 74 (top, center), 76, 81, 83, 85 (top, center), 88, 91 (bottom), 92, 94 (bottom) 95 (top), 100 (top)

Dean Pennala: 39

Wilma Pollock: 20

Steve Price: 54 (original photograph)

Laura H. Sandall: 87 (top)

Susan B. Scopie: 78 (bottom)

Suzanne C. Sopke: 64 (bottom)

Theresa Spillett: 80

Melanie A. Swieconek: 38 (bottom)

Mark Testa: 40

Joseph J. Tobias: 84 (bottom)

Marcelo Valle: 68 (bottom left)

Jeanne Van Alphen: 44

Louise Weston: 36

Javier Zaletas: 90 (bottom)

Image on page 18 courtesy ©Eastman Kodak Comapany.